MULTIPLE EXPOSURE

MULTIPLE EXPOSURE

THE GROUP PORTRAIT IN PHOTOGRAPHY

Leslie Tonkonow, Guest Curator

Essays by Leslie Tonkonow and Alan Trachtenberg

A traveling exhibition organized and circulated by Independent Curators Incorporated, New York

Itinerary

The Bruce Museum
Greenwich, Connecticut
May 7 to June 25, 1995

Bayly Art Museum
University of Virginia
Charlottesville, Virginia
September 1 to October 29, 1995

Oakville Galleries
Oakville, Ontario, Canada
January 13 to March 10, 1996

**1975
ICI
1995**

Lenders

American Fine Arts, Co., Colin De Land Fine Art, New York

Timothy Baum, New York

Stephen Benjamin

Janet Borden, Inc., New York

Sophie Calle

Larry Clark

Davison Art Center, Wesleyan University

Keith de Lellis Collection, New York

Estate of Darrell Ellis

Elliott Erwitt

Fraenkel Gallery, San Francisco

Barbara Gladstone Gallery, New York

Marian Goodman Gallery, New York

Howard Greenberg Gallery, New York

Jeffrey Hoffeld and Company, Inc., New York

Louise Homburger and Bonnie Benrubi

Jeffrey S. Kane

Jan Kesner Gallery, Los Angeles

Karen Knorr

Marvin and Alice Kosmin

Luhring Augustine, New York

Magnum Photos, Inc.

Robert Miller Gallery, New York

Pace/MacGill Gallery, New York

Pigozzi Collection

Sander Gallery, New York

Holly Solomon Gallery, New York

Staley-Wise Gallery, New York

Anne Turyn

Rick Wester

Zabriskie Gallery, New York & Paris

Private Collection

Independent Curators Incorporated

Independent Curators Incorporated (ICI), New York, is a national non-profit traveling exhibition service specializing in contemporary art. ICI's activities are made possible, in part, by individual contributions and grants from foundations, corporations, and the National Endowment for the Arts.

Acknowledgments

I would like to thank guest curator Leslie Tonkonow, Director of the Zabriskie Gallery, for her enthusiastic curatorial work and her thoughtful catalogue essay. I am also grateful to Alan Trachtenberg, Professor of English and American Studies at Yale University, for his insightful essay which sheds further light on the subject of the group portrait.

On behalf of guest curator, Leslie Tonkonow, I would like to extend special thanks to those who have helped in the preparation of this exhibition, particularly Alix Mellis and Sarah Morthland of the Howard Greenberg Gallery; Jeannie Freilich-Sondik and Andrew Richards of the Marian Goodman Gallery; Eleanor Barefoot of the Sander Gallery; Virginia Zabriskie and Tom Gitterman of the Zabriskie Gallery; Kristin Reimer; Mary Doerhoefer of the Robert Miller Gallery; Amanda Doenitz and Amy Whiteside of the Fraenkel Gallery, San Francisco; Ellen D'Oench of the Davison Art Center at Wesleyan University; Tom Farmer of the Holly Solomon Gallery; Allen Frame; Debra Gifford of Pace/MacGill Gallery; Danielle Tilkin; André Magnin; Matthew Whitworth of Janet Borden, Inc.; Klaus Ottmann of the Ezra and Cecile Zilkha Gallery at Wesleyan University; Michael Clegg; Daniel McDonald of Art Club 2000; and Regula Aregger of the Staley-Wise Gallery.

Once again, it is the combined efforts of ICI's outstanding staff — Judith Olch Richards, Lyn Freeman, Jack Coyle, Virginia H. Strull, Alyssa Sachar, Heather Glenn Junker, and Stephanie Spalding — that make possible the realization of each ICI exhibition. Volunteer Jeanne E. Breitbart and interns Carmen Menocal and Megan O'Rourke added immeasurably to this project. The involvement and commitment of each of ICI's Trustees is an invaluable asset, and I gratefully acknowledge their support of each exhibition within ICI's program.

Susan Sollins, *Executive Director*

Multiple Exposure
The Group Portrait in Photography

Leslie Tonkonow

Before the last two decades of the nineteenth century, making photographs was an activity practiced mainly by professionals, scientists, and amateurs with sufficient means and leisure to indulge in an expensive, complicated, and time-consuming hobby. The technological revolution in photography of the 1880s, however, changed all that with the development of small, hand-held cameras that could be used without cumbersome tripods, and the introduction of gelatin-silver plates, which could remain light sensitive for months. These advances freed photographers from needing to be near their darkrooms or devising a way to make them portable. In 1888, George Eastman produced the first Kodak camera — sold pre-loaded with film that was to be returned to the manufacturer for processing. The photo-finishing industry was born and the idea of "photography for everyone" was fast becoming a reality.

Public fascination with photographic portraits began almost simultaneously with the birth of photography in 1839. Hand-tinted daguerreotypes supplanted painted miniatures in the 1840s and 1850s; tintypes, cabinet cards, and *cartes de visites* were widely collected and pasted into albums in the 1860s and 1870s. But before the *fin-de-siècle* inventions that made photography portable and easy, amateurism as we know it did not exist. Because most of the first amateur photographers were either artists or upper-class aesthetes not motivated by economic or utilitarian concerns, they tended to follow the prevailing rules for pictorial representation in painting which dictated a hierarchical order in terms of subject matter. Considering portraiture too specific to convey

the loftier values inherent in history or landscape painting, instead they "concentrated on landscapes, town views, and architecture"[1] while "portraiture remained almost exclusively in the hands of professionals."[2] Those amateurs and professionals who did make portraits mimicked the conventions of portrait painting. But by the end of the nineteenth century, when a vast, new population began to play under the banner of amateurism, the distinctions between aesthetic and practical photography became more pronounced.

As long as photography was perceived as being an arcane and difficult craft, an aura of prestige clung to the practice, without reference to the quality of the work of the individual practitioner. But once photography became, in the Western world, virtually as common as literacy, it lost its craft mystique. Those who wished to advance the reputation of photography "as an art" felt themselves compelled to solve this problem by making categorical distinctions between instrumental photography, which served some social or economic need, and artistic photography, which served only abstract artistic virtue.[3]

At the turn of the century, the definition of photography as an art form, modeled on the modernist theories and practices of the "higher" plastic arts, excluded any socially engaged use of the medium. The modernist paradigm of the artist, engaged in a Promethean struggle for the New, found its counterpart in the romantic image of the photographer — the rugged explorer/adventurer whose far-flung expeditions yielded imagistic trophies of exotic places and things, the intrepid seeker of truth on the battlefield or at the scene of a crime, who spent long hours alone in the dark conjuring spectacular images as if by magic in an alchemical

rush of fluids and focused beams of light. The popular conception of photography as a solitary practice echoes the conventional, modern Western notion of the individual which stresses personal freedom. The call for the right to shape one's own destiny was a rallying cry of the eighteenth-century liberation movements in France and North America that marked the beginning of the modern era and engendered a fundamental idea of the self that has persisted in Western thought throughout most of the twentieth century. The dialectic of the self and the social continued, by extension, at the beginning of the twentieth century in the discourse on the aesthetic and practical uses of photography which divided the medium into two distinct camps, "the goal of one being a record of facts, and of the other an expression of beauty.... It will record facts but not as facts."[4]

In 1900, Eastman introduced a smaller, lighter camera — the Brownie — thus enabling a truly vernacular photography. Because of its size, low price ($1.00), and the fact that its use required little skill and no formal training, this camera became ubiquitous in middle-class life, making possible the social ritual of creating group pictures. The popular conception of portraiture changed radically as the new amateurs, now also members of the middle and working classes, redefined desirable subject matter. While photography, for almost fifty years, had been the sole mode of pictorial representation to cut across class lines in enabling the masses to have their portraits made, the photographer could now also be a "privileged insider,"[5] capable of eliciting the spontaneous emotions and expressions of personality previously prohibited by the lengthy exposures of earlier cameras and proscribed by professional portraitists who adhered to a vocabulary of acceptable gestures and poses. In casual snapshots the new amateurs were "free to photograph the things

that mattered most," including family, friends, pets, and possessions. When they "did group their friends, they were not voyeurs trying to ascertain relationships or personalities, but intimately related to the event being recorded, and their subjects reacted accordingly."[6]

According to Pierre Bourdieu, the camera quickly became a tool for the validation of the family unit through its objectified portrayal. Certain types of images became "consecrated" in terms of their use in helping maintain the integration of domestic life, such as pictures of young children and group photographs taken during important festivities or social occasions, such as weddings:

> The photographic image…was introduced very early and established itself very quickly (between 1905 and 1914) because it came to fulfill functions that existed before its appearance, namely the solemnization and immortalization of an important area of collective life. The wedding photograph was accepted so quickly and generally only because it met the social conditions of its existence: …the purchase of the group photograph, a conspicuous consumption which no-one can escape without loss of face, is felt to be obligatory, as a homage to the married couple…. If one accepts…that the function of the festivity is to revitalize and recreate the group, one will understand why the photograph is associated with it, since it supplies the means of solemnizing those climactic moments of social life in which the group solemnly reaffirms its unity.[7]

The group portrait was not a common motif until it emerged in the twentieth century as a social ritual. As more people more frequently photographed themselves and each other, group portraits made by professional photographers became increasingly commonplace as well and their creation continues as a feature of contemporary social life. Whenever people gather officially in groups — whether they are dining at a banquet table, participating in a beauty pageant, playing on a baseball team, or attending a costume party — the group portrait has become a kind of ritualistic punctuation mark, attesting to the unification of the participants in time and purpose. The photograph symbolizes feelings of spiritual harmony and intellectual solidarity; it documents familial bonds, political affinities, membership, and professional alliances.

In 1913, two residents of Zion City, Illinois, a newly formed religious community, joined together to create a unique expression of spiritual unity and communal devotion through the group portrait. Arthur S. Mole, a photographer, assisted by John D. Thomas, the church choir director, compelled hundreds of his fellow worshipers to stand together in formations of crosses, crowns, and other Christian symbols for the sole purpose of making a photographic record of their common faith. When the United States entered the first World War, the religious iconography of what Mole called the "Living Photographs" was replaced by patriotic symbols, as the team began to make even larger, more complex formations involving thousands of American troops joined together in *The Living American Flag* (not included in the exhibition), *Human American Eagle* (1919), and *The Living Uncle Sam* (1919).[8] Similarly, Eugene Omar Goldbeck, a contemporary of Mole's now remembered mainly for panoramic portraits of groups, created what is probably the best-known group portrait in formation. On July 19, 1947, after six weeks of preparation, he photographed the Indoctrination Division, Air Training Command, at Lackland Air Base, in celebration of

the fortieth anniversary of the United States Army Air Force. 21,765 men stood in insignia formation, with all of the black troops segregated into the circular center and in lines at the top of the image.

While these pictures may be viewed as odd relics from times past, their subtexts address the idea of power, a subject more recently explored in photographic group portraiture by Clegg & Guttmann. In the formations of Mole and Thomas and Goldbeck, the power of institutions such as the Church and the Military is explicit, but there is also an implicit power in the relationship of the photographers to their thousands of subjects. Roland Barthes perceived photography as "a kind of primitive theatre," a "*tableau vivant.*"[9] Here the act of producing the photograph becomes an intersubjective experience of the spectacle, as directed by the photographer. The ultimate meaning of the photograph may not lie in the depiction of its subjects, nor in the symbols they portray collectively, but rather in its making.

Bourdieu's description of photographic practice as "a ritual of solemnization and consecration of the group and the world" that "perfectly fulfills the deeper intentions of the 'popular aesthetic,' the festive aesthetic...of communication with others and communion with the world"[10] speaks to a universal need that impels people throughout the world to document their gatherings and relationships to one another. This universality can be seen in photographs of groups by Martín Chambi, Mike Disfarmer, and Seydou Keita.

Chambi's legacy, consisting of 14,000 glass plate negatives discovered after his death, is a comprehensive documentation of Peruvian culture. His many portraits of groups, made mainly in the period between the two World Wars, depict all strata of Cuzco society, from agricultural and factory workers to the *haute bourgeoisie*. Chambi's subjects have been photographed in natural light on location, in social spaces that inform their identities as groups. By contrast, the residents of the tiny community of Heber Springs, Arkansas, photographed in the 1930s and 1940s by the iconoclastic Disfarmer, are presented in stark relief, posed against a black curtain or a taped white wall. Disfarmer's portraits provide a rare inside look at a poor rural community from a period in American history mainly remembered through images by FSA (Farm Security Administration) photographers such as Walker Evans or Dorothea Lange, "outsiders" whose purposes were either artistic, socio-political, or both. Disfarmer's subjects, however, unlike those of Evans and Lange (and like those of Chambi and Keita), participated more actively in the ritual of the portrait by initiating it. Before the end of the second World War, a visit to the Disfarmer studio was a highlight of Heber Springs social life.[11] Disfarmer's subjects posed for themselves as they confronted his lens, the emptiness of the studio underscoring in the photographs a sense of the closed, inbred community in which they lived. It is this same sense of closure that objectifies the subjects so that the photographer's presence dominates. While Disfarmer may not have intended to produce works of art, it is surely because of his own odd personality that his photographs are now perceived as such, beyond their value as interesting sociological documents. He had virtually no friends and had cut himself off completely from his family. The figures in his pictures, though they may appear in family groups, are similarly isolated in a manner curiously suggestive of portraits by Richard Avedon and Irving Penn in which the intentions of the photographers overshadow the identities of the individuals, portrayed similarly without context.

From the late 1940s until 1975, Seydou Keita photographed the residents of Bamako, the capital of Mali, becoming its best known photographer. He worked mainly out-of-doors, posing his clients in front of a cloth draped against a mud or stucco wall. Because Keita changed the cloth every two to three years, it now serves to help him date the more than 10,000 negatives that he has managed to save. In his photographs, the cloth backdrop does not serve to define the space or, as in Disfarmer's work, contribute to a psychological atmosphere, but appears instead as a self-conscious element that accentuates the distressed wall it was meant to cover and the pebble-strewn ground on which his subjects stood. When Keita selected a backdrop with a densely patterned design, it became a pictorial device that related to the similarly patterned dresses of many of his female clients. All of Seydou Keita's pictures were commissioned by his subjects, who often wanted to be photographed with important possessions, such as a guitar, gun, or car. For those who arrived empty-handed and so desired, he would lend something of his own such as a bicycle, radio, or even clothing.[12]

What is most striking in the group pictures of Keita, Chambi, and Disfarmer is the similarity of the poses. Staring, considered impolite (if not dangerous) in many societies, characterizes the confrontational poses seen in the works of all three. The subjects look straight at the camera, some perhaps smiling tentatively, as they gaze directly into the lens in a kind of mirroring of the self that is multiplied in the group context because of the common consciousness that all are being photographed. There is a shared awareness, not only of the camera and the photographer, but also of the instant the shutter is released. The dual portrayal of individual and group identity, the relationships of the subjects to each other, and the sublimation of individual identity to that of the group distinguish portraits of groups from those of individuals.

Just as the evolution of a vernacular pictorial language in photography initiated the distinction between amateur and artist, the group portrait, paralleling the populist practice of the medium, appears within all the major artistic developments in modern photography from the early 1900s to the present.

In a 1931 essay, Walter Benjamin commented: "'There is no work of art in our age so attentively viewed as the portrait photography of oneself, one's closest friends and relatives, one's beloved,' Lichtwark wrote as early as 1907, and thereby moved the investigation out of the realm of esthetic distinctions into that of social functions. Only from that angle can it strike out further. It is significant that the debate becomes stubborn chiefly where the esthetics of *photography as art* are involved, while for example the much more certain social significance of *art as photography* is hardly accorded a glance."[13]

From 1910 until his work was interrupted by the Nazis in the early 1930s, August Sander, an avatar of socially involved photographic art, was engaged in one of the most ambitious projects in the history of photography, an attempt to create a collective portrait of the German nation through photographs of its people. Working within a pseudo-scientific system influenced by Immanuel Kant's writings on physiognomy, which determined that character and disposition were revealed through facial characteristics (and generally accepted in German thought from the eighteenth century through the end of National Socialism), Sander classified his subjects as social types beginning with peasants, "'ascending'

through small-town people, workers, bourgeois, students, politicians, revolutionaries, clergy, professional people, industrialists, artists, writers, and musicians; and then 'descending' through bar waiter and cleaning woman" to the mentally disabled at the bottom.[14] Allied with the *Neue Sachlichkeit* movement in painting in its quest for truth, Sander's method countered the mainstream avant-garde of his time, represented by the Bauhaus which stressed formal experimentation. Although photography was not officially taught there until 1929, it was present throughout the 1920s in the cultish devotion of the students to taking group portraits.[15] T. Lux Feininger's photograph of eight of his fellow students dancing on the Bauhaus roof (*Group 'Charlestoning' on Bauhaus Roof,* 1920s) is typical of the silly antics in many of these pictures, meant to poke fun at the serious dialectics embodied in its institutionalization of modernism.

While the formal devices typifying serious photographic practice at the Bauhaus (montage, collage, abstraction) paralleled modernist "advances" in painting and sculpture, Sander's art appears more contemporary in retrospect. The systemic, reductive nature of his work foreshadows the minimal and conceptual art of the 1960s and 1970s, particularly the photographs of Bernd and Hilla Becher.

In 1969, the group portrait became the focus of a conceptual project initiated by the critic Lucy Lippard. As a result of her involvement with the "undifferentiated" images of Ad Reinhardt, the serial works of Sol LeWitt, and her prior "commitment to a dematerialized or 'conceptual' art emphasizing photographic documentation and words,"[16] Lippard formulated a set of detailed instructions which she sent to about thirty artists, including Douglas Huebler, Jonathan Borofsky, Adrian Piper, Lawrence Weiner, and Alex Katz. She asked each to "photograph a group of five or more people in the same place, and approximately the same positions in relation to each other, once a day for one week. (No posing or gimmicks, no diversion from the conventional group photo taken for school yearbooks, Knights of Columbus annual picnics, etc.)"[17] The resulting twenty-two responses were exhibited at the School of Visual Arts in October of that year. Lippard selected the group portrait as a subject "because of personal preoccupations," wondering "if the expression on people's faces would produce a kind of subliminal plot,"[18] although the psychology of group portraiture was not inherently of interest to her. Lippard's project typified the use in the 1960s and 1970s of the deadpan photographic image as a signifier of cultural information by artists such as Ed Ruscha, John Baldessari, Dan Graham, and the Bechers.

In the mid-1970s, at the start of his career, Nicholas Nixon was among a group of young photographers whose work reflected this cooler attitude by adopting a more formal, emotionally distanced approach than the previous generation of Leica-carrying "street" photographers. The "new objectivity" in Nixon's work was accomplished with an 8 x 10 inch view camera which he used to photograph unpopulated urban scenes. In 1975, he shot the first of his annual portraits of his wife Bebe and her three sisters. While sharing some of the formal aspects of his topographic work, Nixon's photographs of his wife and sisters-in-law arose out of a curiosity about siblings — having none of his own. He regarded the first portrait as a larger-than-usual family picture — something one would paste into an album or reproduce on a Christmas card. After the third picture, *The Brown Sisters* (1975–94) became a series.

Nicholas Nixon's pictures of the Brown Sisters are empathic mirrors of common experience, formally posed portraits shot in snapshot style by a family member who is a recognized master of visual inflection. The occasion of the photograph is an annual event with the photographer and his subjects adhering to a system in which the sisters agree to pose every year in the same standing position (from left to right, Heather, Mimi, Bebe, and Laurie), all looking at the camera. While these widely published images have come to symbolize familial bonding in depicting the ways in which the sisters are alike, they also express four distinct personalities and how each has changed over time. The series has become the definitive essay on the passage of time with Nixon using his camera, to paraphrase Barthes, as "a clock for seeing."[19]

Since the early 1980s, group portraiture has appeared with increasing frequency in contemporary photographic art. Clegg & Guttmann's discursive photographs comment on the structure of power embodied in group portraits taken for corporate annual reports while deconstructing this form in a parody of the poses and gestures in seventeenth-century Dutch portrait painting. Thomas Struth's photographs of families and other kinds of groups, made from 1987 through 1990, are investigative portraits of relationships influenced by the vernacular family snapshot, "the ones already to be found in every drawer and box of every family."[20] Posed groups of people have appeared in recent works by Tina Barney, Sophie Calle, Karen Knorr, Richard Prince, and many other artists in Europe and the United States. Art Club 2000, a collective of seven young artists, critiques commodity and the cult of personality through group portraits of themselves.

Why at the end of the twentieth century, have artists and photographers chosen to work within the format of a social practice that began at the end of the nineteenth century?

Current economic trends and shifting cultural attitudes are evidence that the modernist emphasis on the individual no longer obtains in a postmodern era. As smaller businesses are subsumed or replaced by larger ones, consumer choices are delimited by corporate decisions, producing an increasingly homogeneous world. Fundamentalist religions, in which the direct relationship of oneself to one's God is often mediated by political ideology, are becoming more popular. Recent scientific studies postulating the existence of aesthetic universals claim to disprove the ancient cliché that beauty is *subjectively* in the eye of the *individual* beholder. Psychoanalysis is in disfavor. Fashion magazines seem to feature models that are more often grouped. Artists are no longer impelled to struggle against history alone, frequently working now in teams or collectives. Society at large is less individualistic and thus, by default, more group oriented, as what one eats, wears, watches on television and in the movies, and reads in the newspaper becomes more and more the same, while statistical evidence points to the disintegration of the most basic social group — the family.

With the prevalence of the photographic group portrait in contemporary art, the debate on the self and the social has come full circle. The significance of *art as photography* is no longer in question. All modern art can be viewed in some capacity as a search for the self. Perhaps this quest is no longer made by turning inward, but by examining the relationship of oneself to others. ●

Notes

1 Helmut & Alison Gernsheim, *The History of Photography* (New York: McGraw-Hill, 1969), p. 234.

2 Ibid.

3 John Szarkowski, *Photography Until Now* (New York: The Museum of Modern Art, 1989), p.159.

4 Ibid.

5 Sara Greenough, "The Curious Contagion of the Camera," in *On the Art of Fixing a Shadow: One Hundred Fifty Years of Photography* (Washington D.C.: The National Gallery,1989), p. 132.

6 Ibid.

7 Pierre Bourdieu, *Photography: A Middle Brow Art.*, 3rd ed., trans. Shaun Whiteside (Stanford, CA: Stanford University Press, 1990), pp. 20–21. Bourdieu is a French sociologist who published a landmark study on the social uses of photography in France, in 1965.

8 I am grateful to Larry A. Viskochil, Curator of Prints & Photographs, Chicago Historical Society, Chicago, IL, for contributing information on Mole and Thomas.

9 Roland Barthes, *Camera Lucida*, 2nd ed., trans. Richard Howard (New York: Farrar, Straus & Giroux, Inc., 1981), p. 32.

10 Pierre Bourdieu, *Photography: A Middle Brow Art,* p. 94.

11 "It was a fad, kind of, to go and have a hamburger and have a picture made." Julia Scully, *Disfarmer* (Danbury, NH: Addison House, 1976), p. 5.

12 I would like to thank André Magnin, an independent curator based in Paris and curator of the Contemporary African Art Collection, Geneva, for contributing his direct knowledge of Seydou Keita and his work.

13 Walter Benjamin, "Walter Benjamin's Short History of Photography," trans. Phil Patton, *Artforum* , Vol. XV, No. 6 (February 1977), p. 50.

14 Robert Kramer, *August Sander: Photographs of an Epoch* (Millerton, NY: Aperture, 1980), p.11.

15 The idea of a cult of group portraiture at the Bauhaus is introduced by Andreas Haus in "Photography at the Bauhaus: Discovery of a Medium," in *Photography at the Bauhaus*, ed. Jeannine Fiedler (Cambridge, MA: MIT Press, 1990), p.133.

16 Lucy Lippard, "Groups," *Studio International,* Vol. 179, No. 920 (March 1970), p. 93.

17 Ibid.

18 Ibid.

19 Roland Barthes, *Camera Lucida* (New York: Farrar, Straus & Giroux, Inc., 1981), p. 15.

20 Thomas Struth, "Interview Between Benjamin H. D. Buchloh and Thomas Struth," in *Thomas Struth: Portraits* (New York: Marian Goodman Gallery, 1990), p. 36.

Bibliography

Barthes, Roland. *Camera Lucida*. Translated by Richard Howard. New York: Farrar, Straus & Giroux, Inc., 1981.

Benjamin, Walter. "Walter Benjamin's Short History of Photography." Translated by Phil Patton. *Artforum* XV, 6, February 1977.

Bourdieu, Pierre. *Photography: A Middle Brow Art,* 3rd ed., trans. Shaun Whiteside. Stanford, CA: Stanford University Press, 1990.

Britt, David. *The Photograph: A Social History*. New York: McGraw Hill, 1966.

Buchloh, Benjamin H. D. "Interview Between Benjamin H.D. Buchloh and Thomas Struth." In *Thomas Struth: Portraits* (exhibition catalogue). New York: Marian Goodman Gallery, 1990.

Davenport, Marguerite. *The Unpretentious Pose: The Work of E.O. Goldbeck, A People's Photographer*. San Antonio, TX: Trinity University Press, 1981.

Galassi, Peter. *Nicholas Nixon: Pictures of People* (exhibition catalogue). New York: The Museum of Modern Art, 1988.

Gernsheim, Helmut & Alison. *The History of Photography.* New York: McGraw-Hill, 1969.

Greenough, Sara. "The Curious Contagion of the Camera." In *On the Art of Fixing a Shadow: 150 Years of Photography* (exhibition catalogue). Washington, DC: The National Gallery, 1989.

Haus, Andreas. "Photography at the Bauhaus: Discovery of a Medium." In *Photography at the Bauhaus,* ed. Jeannine Fiedler. Cambridge, MA: MIT Press, 1990.

Lippard, Lucy. "Groups." *Studio International*, Vol.179, No. 920 (March 1970).

Kozloff, Max. "Chambi of Cuzco." *Art in America* (December 1979).

Kramer, Robert. Preface by Beaumont Newhall. *August Sander: Photographs of an Epoch*. Millerton, NY: Aperture, 1980.

Scully, Julia. *Disfarmer.* Danbury, NH: Addison House, 1976.

Szarkowski, John. *Photography Until Now* (exhibition catalogue). New York: The Museum of Modern Art, 1989.

Trachtenberg, Alan. *Reading American Photographs.* New York: Hill and Wang, 1989.

The Group Portrait

Alan Trachtenberg

Why do group portraits fascinate us? Is it because they give us more to look at, or that they offer more attractions to draw us into the picture? Who, we ask, are these people? Why are they together in a picture? Is there a story here, something to uncover, secrets for us to savor? Like novelists, photographers of groups capture our attention by tacit means as much as by overt ones, by the import of a look, a touch, a way of sitting or standing. These are clues to meanings we can only guess at. And group portraits in turn make novelists out of us, testing our skills at deciphering body language, at imagining plausible narratives. They excite our imaginations with the prospect of delving into complex realities, digging beneath surfaces, and ferreting out truths from appearances captured with the stop-action speed of the camera. Group portraits come laden with a surplus of information, but there's always more we want to know — about the group's history, its inner dynamics.

We wonder about the role of the photographer in shaping the picture. How much comes from his or her intentions, how much from the will of the group? Group portraits arouse more questions than they can answer, and thus they seem paradoxically open *and* closed, easy to understand and utterly inscrutable. Fascination seems the perfect word for their contradictory effects.

Multiple Exposure: The Group Portrait in Photography surveys the hold of this kind of picture, this genre, upon serious photographers and viewers in the twentieth century. Some of the photographs in the exhi-

bition hew to the conventional formats employed by amateurs as well as professionals, placing subjects in rows or clusters with appropriate props. Within the familiar conventions some photographers seem more concerned with the group as a whole, how the subjects fill the space and compose a totality; others focus their attention on the equilibrium between individuals and the group, how the separate figures look as part of a group. Still others seem to play with convention, to stage scenes in a way that makes the convention itself part of the scene, an ironic presence. The exhibition brings together an assortment of artistic motives, from documentary to commemorative, from modernist to post-modernist. The sheer variety of aesthetic and political agendas which have found a place for the group portrait is enough to convince us of the vitality and complexity of the genre.

The first step toward comprehending its appeal is to define its most obvious traits. One thing certain about a group portrait is what it is: people showing themselves together before a camera. The size of the group matters less than the purpose and function of the picture, which is always to ascribe an identity and to give it a name: these folks are baseball players, soldiers, airline stewardesses, engineers, circus performers, cops. Here's a family — father, mother, brother, and sister, and the house dogs. Some groups have in common the fact that they look like each other and seem comfortable in their domestic space. Others wear the same uniform or no clothes at all; nudity makes for the simplest, most radical kind of uniformity, and also reveals the most particular kinds of difference. For other groups it's objects that reveal who they are — motorcycles, a huge lens held in the lap, a banquet table. A depicted group may share a social predicament — as refugees, or people living in poverty on the street. Or groups may share nothing more than being in the same place together, at a convention, wedding, or a graduation. Typically these are commemorative pictures, souvenirs of an event. In such pictures the ascription of identity usually requires nothing more than some indication of the place and the event. In all cases, as we see in *Multiple Exposure*, there is an identifying mark, a shared attribute that explains why these people are together, what makes the photograph a group portrait rather than a random assortment of individuals.

Still, there's something else, a reason, purpose, or inner drama only hinted at. In albums, or on walls of homes, offices, and schools, group portraits reassure us with a sense of continuity. But then, there's a paradox, something mysterious lurking within the familiar. The group setting changes the way individuals look and feel. Are they less themselves, or more so? How does the group affect our perception of the separate figures? Are groups in photographs something more than the sum of their parts? Do they seem to be persons in their own right, perhaps more real than their component parts?

For one thing, groups double the identities of their members. Here we have Nicholas Nixon's *The Brown Sisters* (1975–94): each has a name, a distinctive appearance, a life history or a "case" in her own right. Yet each is also one of the Brown Sisters. "One's-Self I sing," wrote Walt Whitman, "simple separate person," "yet utter the word Democratic, the word En-Masse."[1] Certainly not all groups look democratic, but they do look "en-masse," an ensemble made up of separate persons. Whitman worried a good deal about the connection, the nexus, between persons and masses, how the "I" belonged to the "we," the

"me" to the "us." Looking at group portraits can get us wondering about the same issue, the dialogic character of identity. What does it mean to say of the Brown Sisters that they are, as depicted by Nicholas Nixon, separate yet together, each herself yet also not herself, a figure in a group? Groups seem to subtract something from their members, some aspect of separateness, even as they add something, an identity that comes from belonging in some measure to others. Serious, innovative group portraiture such as Nixon's touches some of the deepest issues of both private and collective existence, especially the relation between likeness and difference, and difference within likeness.

Group portraits engage us as observers of social situations in which identities shift and slide between persons and groups. But before we entangle ourselves in the logic of identity, we should ask what we mean by portrait in the first place. There's a double edge to the word "portrait." "To portray" means simply to picture, to represent, to delineate. But except by a stretch of the term not every picture of a person or group has the status of portrait. A news photo of an unnamed woman weeping over the body of her husband in a village in Haiti is a portrait only by a generous extension of the term. True, it's a picture of a person, but more important, it's a picture of an event in which the exact identity of the figure hardly matters. Her role in the picture is not to represent herself as a distinct and unique person, but to exemplify a certain horror. Similarly, the famous picture of marines raising the flag on Iwo Jima is a picture of an action, a symbolic event, rather than a portrait of a specific group of persons. The identities of the figures fade into the identity of the event. In both cases a symbolic meaning overshadows the particulars of personhood.

In a portrait it matters first and last who the represented figures are. If the subjects are not shown as persons representing themselves before a camera, the picture cannot properly be called a portrait. In his book on portraiture, Richard Brilliant places the burden of definition on the intention of the artist. A portrait is a picture of actual people being themselves. And function follows from intention. "The very fact of the portrait's allusion to an individual human being," writes Brilliant, "actually existing outside the work, defines the function of the art work in the world and constitutes the cause of its coming into being."[2] This useful criterion rules out pictures which may indeed show people but are not made exactly for the purpose of showing them, like news photos or street scenes. Quoting the philosopher Hans-Georg Gadamer, Brilliant calls this intended relationship to an original "occasionality."[3] What occasions a portrait is the desire of the artist that this picture be seen and recognized as having a precise relationship to a specific person or persons. Occasionality is the name of a function; without that purpose, a picture is not a portrait. Pictures of people that we look at exclusively as works of art are not portraits. Portraits are defined by their social function: to put us in the presence of an image of specific people who possess given names and appearances recognizable to an intended audience.

That immediacy of purpose is placed at one remove when the pictures appear in an exhibition such as *Multiple Exposure*. Exhibited pictures take on a pedagogical purpose, to teach us something about the genre itself. We don't visit the exhibition to see specific faces and bodies but to see how photographers have treated the function of representing people in groups. And what we see, what we learn, is that groups can

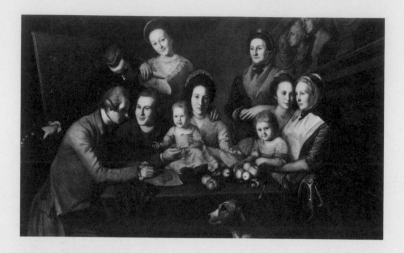

Charles Willson Peale
The Peale Family, c. 1770–73 and 1808. Oil on canvas, 56½ x 89½ inches.
Collection New-York Historical Society

In the tightly composed small groups depicted in photographs by August Sander, Walker Evans, Diane Arbus, Mike Disfarmer, Seydou Keita, and others, group and individual seem equal in interest. The group provides an identifying context for the individuals; the self-presentation of each person seems conditioned by the presence of the others. Each seems to be aware of being part of a small, integral group, aware of sharing an identity larger than that of the separate self. These works possess a certain formality, a mark of deliberateness in the pose and the composition, doubtless the product of collusion between photographer and group — evidence of a mutual desire to present the group as a meaningful setting for each member. They show the group and the individual in equilibrium, the image of communal relations meaningful to each participant.

sometimes take on the character of persons in their own right, that photographers sometimes treat the group rather than the individuals who comprise it as their referential subject, their primary occasion. Pictures representing collective events, such as Martín Chambi's *Carnival Costume Party* (c. 1930), James VanDerZee's *Untitled* (Children Swimming) (1928), and Weegee's *Butcher's Strike* (1943), illustrate this subordination of person to group. The defining examples are pictures in which individuals disappear as such, serving only as integers of a group, as in Eugene Omar Goldbeck's *Indoctrination Division* (1947), and the Mole and Thomas pictures, *Human American Eagle* (1918) or *The Living Uncle Sam* (1919). In these pictures, men in uniform act out an obliteration of individuality on behalf of the most potent group identity of modern times, the military branch of the nation-state.

Richard Brilliant's comments about seventeenth-century Dutch group portraits describe the motives and the effects of these photographs:

> In Dutch group pictures, the integrated ensemble may prevail over the independent individual, but in them the strong emphasis on the realistic depiction of specific individuals permitted each person's portrait to compete for close, if momentary, visual and pyschological attention. The Dutch artists seemed to compel the viewer's eye to move from face to face, never losing sight of the others in the contemplation of the one....each person in the group contributes to, and draws from, the presentational dynamic of the whole.[4]

The paintings in mind here represent groups as corporate entities, families, or guilds or voluntary associations such as assemblies of artists or philosophers, and include within the painting some emblem of the group's identity. Groups by Rubens and Hals and later painters reveal

"the outward expression of each actor's personhood by virtue of his participation in the group, the very participation that gives meaning to his life as an individual and offers to him a part of his identity that he shares, willingly, with others."[5]

A compositional convention frequently employed by painters shows the group arranged as if in conversation, in poses of studied informality. The device has special force in the portrayal of family groups, where the air of informal activity conveys the theme of harmonious concord.[6] Charles Willson Peale's *The Peale Family* (c.1770–73 and 1808) depicts the family seated around a table while one brother (the artist himself) gives a drawing lesson to another. The picture abounds with signs of art, including the row of busts, which can be identified as heads of famous artists. Aware of each other and of the invisible viewer in front of the painting, the group invites its audience into the picture and makes the viewing of this happy, cheerful scene part of the action of the picture. Nineteenth-century photographers occasionally employed the conversation piece to similar effect, showing a family group, as in John Adams Whipple's *Henry Winthrop Sargent and His Family* (c. 1855), absorbed with each other in family activity in a studio version of a parlor setting. By showing families in what they and the artist contrive as their most typical outward form of togetherness, the conversation piece was especially appropriate in delineating family hierarchies and gender roles, differences between fathering and mothering, for example, implied in the Whipple picture by the leaning father and the seated mother.

Perhaps because of its inescapable staginess when photographed, the conversation piece has virtually disappeared from family group photography, but we may detect a trace of it in Tina Barney's decentered

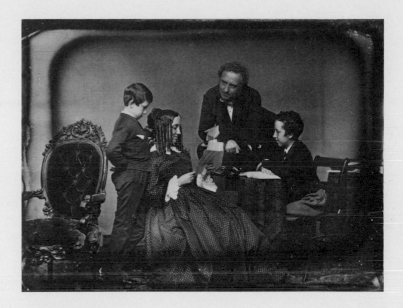

John Adams Whipple
Henry Winthrop Sargent and His Family, c. 1855. Half-plate Daguerreotype. Gift of Aimee and Rosamund Lamb, 1982, Boston Athenaeum

21

snapshot-like depictions of not very happy suburban family life, and in recent ironic restagings of old conventions. On the whole, the family portraits in *Multiple Exposure*, including Nixon's series, have eliminated theatrical absorption (the group seeming to be unaware of the camera while engaged in some activity) for the sake of the frontal view, all eyes centered on the camera lens, a modernist convention which developed in early commercial studies and became the standard vernacular form for group pictures. Frontality is taken as proof of authenticity, of the truth-endowing powers of the camera. We encounter it in Gordon Coster's occupational groups of pilots (*Untitled*, 1940s) and stewardesses (*Untitled*, 1940s) and Robert Johnson's *Life* photographers (*Untitled*,

1940s), and in recent appropriations of vernacular styles by Jeffrey S. Kane and Frédéric Brenner.

Walker Evans's *Bud Fields, Cotton Sharecropper and Family* (1936) offers a classic sophisticated example of the vernacular style of family portraiture in which there is minimal staging by the photographer. Each figure sits or stands frontal to the camera; each represents himself or herself as she or he is solely for the sake of a picture together, not pretending to be other than they are. Forthright depiction of the individuals makes them extraordinary presences in their own right and, collectively, a family group fulfilling the expected decorum of a group picture. The group follows the rules of the genre perfectly, with one glaring exception. They have not made themselves pretty for the occasion. Unlike more "proper" middle-class folk, they allow themselves to be pictured in the everyday garb of working sharecroppers: the daughter in a dirty shift, the father without a shirt, the boy without pants or any covering of his private parts, five of the six figures barefoot. But they have arrayed themselves, no doubt in cooperation with the photographer, in the decorous manner which by convention represents their togetherness, their family identity. The function of the picture is to portray this group of dirt-poor rural people precisely as a family, "exactly themselves beyond designation of words," as James Agee writes in *Let Us Now Praise Famous Men* (1941), the text which this picture originally accompanied.[7] The room they occupy belongs to that shared identity; the unevenly whitewashed walls and the bedraggled iron bedstead extend the meaning of poverty into domestic things; a clipping inexplicably tacked to the rear wall shows some barely legible photographs and caption ("The Little Drakes," Agee tells us[8]).

As Brilliant points out, conventions for depicting family groups include delineations of hierarchy, of authority, and subordination. Here, Bud sits on a plane equal with his mother-in-law, Miss Molly, on his left, and his young wife, Ivy, to his right. What sort of authority does the man exercise? Does the picture clarify relationships, not just actual kinship but psychological relations? He's fifty-nine years old, Agee informs us, and she's in her mid-twenties. Does the boy with exposed immature phallus (he's three years old) standing between Bud's legs express something about the father's own phallic powers? To Bud's immediate right stands eight-year-old Pearl of the depthless eyes, daughter of Ivy and an earlier common-law husband. Agee's text supplies information which supplements the image but only deepens its mystery, the sense that there are dense stories to be unfolded here, layer by tattered layer. What do the facial expressions, the ways of looking into the camera, the choreography of eyes, invite us to believe? Or the way bare feet variously claim a hold upon the bare wooden plank floor? Or Miss Molly's worn brogues? Visual allusions to Van Gogh's peasants and their appurtenances are no small part of this portrait's ascriptive function and its memorable affect.

Allusiveness of a different sort, not to enhance but to deconstruct the image, characterizes another cluster of the portraits in *Multiple Exposure*. The post-modernist works included here stage conventions in order to expose them, to make the viewer's recognition of artifice part of the picture. Works by Sophie Calle, Clegg & Guttmann, Karen Knorr, and Anne Turyn can be called group portraits only in the sense that they place the name of the genre in quotation marks, a "problem" cited in the image rather than a functional experience of representation. Several of these works include pictures within their frame, literal quotations. Some include texts which complicate the image. Karen Knorr's *If*

Community life is to be Lived at its Best (1981–83) presents both. The "real" scene appears as an uncanny mirroring of the portrait over the mantel. The text provides a political message, a commentary on the mirror-like replication of elite male authority from one generation to the next. The picture portrays people, we might say models, portraying themselves in the manner of a group portrait. Who they are in themselves does not matter. They are performers staging the artist's conception of the insidious power of "the Few" to reproduce itself in portraiture (and even to remake a woman into a man's role). The group portrait as a genre thus implicates itself in the social structure of power and its reproduction; it is exposed here as an instrument of "the Desires of the Few." The function of the image is, then, ideational and political rather than portrayal; the picture does not intend to represent its figures as real persons but to deploy them within a conceptual construction. Skepticism toward the possibility of group portraiture of the vernacular-modernist sort underlies the post-modernist examples, a skepticism that seems to extend toward identity as such — as if the figures in these images perform roles because provisional identities derived from previous pictures are the only identities available. The message of these works seems to be that it is no longer possible to distinguish theatre from real life, persons from their performances.

The post-modernist examples in *Multiple Exposure* might be called counter-portraits. Their self-consciousness about convention, their view of identity as performance, add a dimension of disbelief. Their presence makes it difficult for viewers to accept the claims of realism in such pictures as Walker Evans's and Nicholas Nixon's without qualms and hesitation. Viewers of the exhibition will find themselves caught up in a contest over meanings and over the ramifications of the medium. Some

may conclude that the traditional function of portrayal has reached its limits — others, that the strongest images remain those which take the reality of their subjects as a given and strive to portray them in a manner sensitive to both individual and group identities. At the heart of the exhibition lies a set of questions about the dynamic relation between person and group, questions which lead beyond the frame of pictures into the fabric of daily existence. The state of community life, relations between likeness and difference, contested national identities: these insistent issues of the moment press themselves within the horizon of the group portrait. The portraits share with the transactions of everyday life an implicit question about transformations. How does an "I" become a "we," a "me" become an "us?" Whitman's question haunts the group portrait with a pointed contemporary relevance. What is it, then, between us, between the single separate self and the word en-masse, the word democratic? The pictures may have no clear answers but they show that the question cannot be avoided. ●

Notes

1 Walt Whitman, "One's-Self I Sing," from *Leaves of Grass*.
2 Richard Brilliant, *Portraiture* (Cambridge, MA: Harvard University Press, 1966), p. 8.
3 Ibid., p. 7.
4 Ibid., p. 93.
5 Ibid., p. 96.
6 See Mario Praz, *Conversation Pieces: A Survey of the Informal Group Portrait in Europe and America* (London: Methuen & Co, 1971).
7 James Agee and Walker Evans, *Let Us Now Praise Famous Men* (Boston: Houghton Mifflin, 1980), p. 100.
8 Ibid., p. 191.

Alan Trachtenberg is the Neil Gray, Jr. Professor of English and American Studies at Yale University. He is the author of *Reading American Photographs: Images as History, Matthew Brady to Walker Evans*; *Brooklyn Bridge: Fact and Symbol*; and *The Incorporation of America: Culture and Society in the Gilded Age*.

The photographs that follow appear in chronological order.

Dimensions refer to print size unless otherwise indicated.

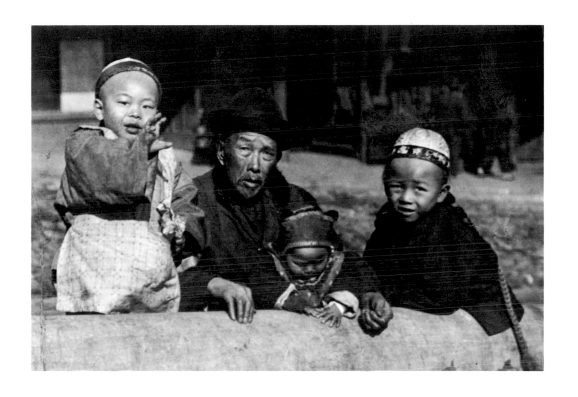

21

Arnold Genthe *Old Chinatown*, c. 1909. Vintage gelatin silver print, 5½ x 8⅞ inches

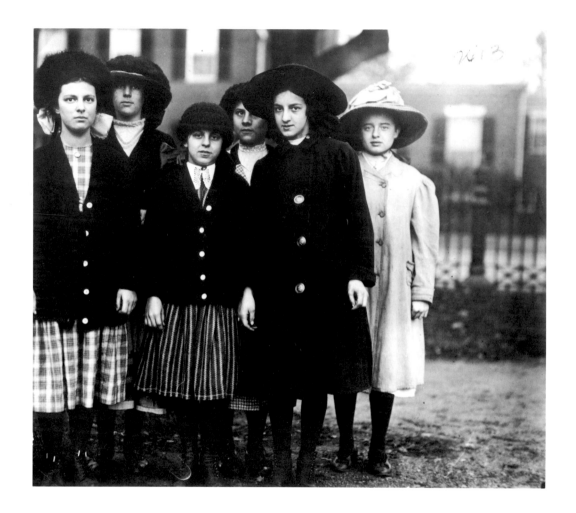

28

Lewis Hine *Untitled* (Six Girls), 1910–12. Vintage gelatin silver print, 4¾ x 5½ inches

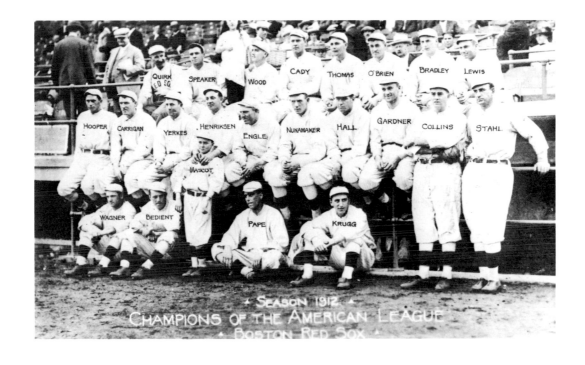

Anonymous *Boston Red Sox Baseball Team (Champions of the American League, Season 1912)*, 1912. Vintage gelatin silver postcard, 3½ x 5⁷/₁₆ inches

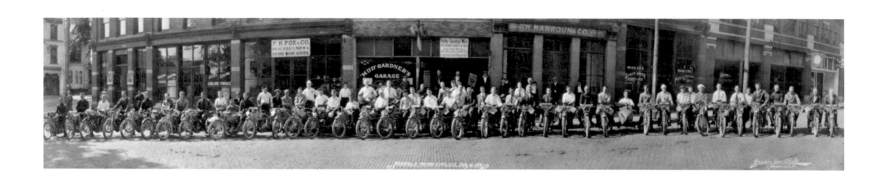

Burckholder *Mansfield Motor Cyclists*, July 18, 1915. Vintage gelatin silver print, 8¾ x 37¼ inches

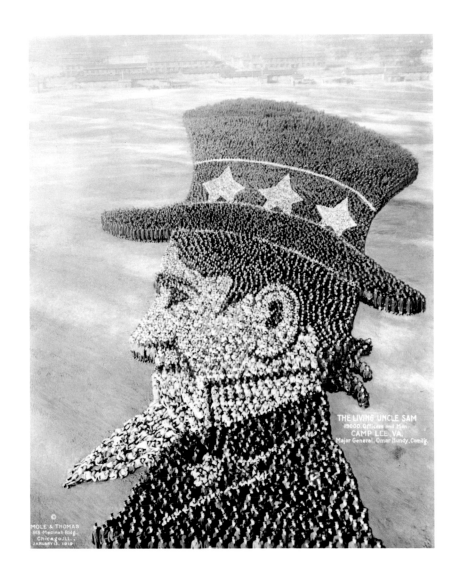

Mole and Thomas *The Living Uncle Sam*, Camp Lee, January 13, 1919. Vintage gelatin silver print, 14 x 11 inches

T. Lux Feininger *Group 'Charlestoning' on Bauhaus Roof*, late 1920s. (From left to right: Heinz Loew, Josef Albers, Andor Weininger, Clements Roseler, Werner Jackson, Marcel Breuer, Heinrich Koch, and Xanti Schawinsky.) Vintage gelatin silver print, 3¼ x 4½ inches

Anonymous *Bauhaus Party*, c. 1928. Vintage gelatin silver print, 3¼ x 4⅝ inches

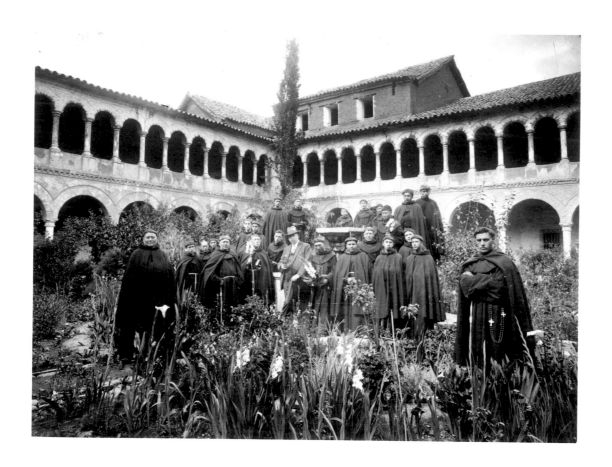

Martín Chambi *Franciscanos con el Señor Blaisdell* (Mr. Blaisdell in the Franciscan Community), c. 1928. Gelatin silver print, 6¹³⁄₁₆ x 9⅛ inches

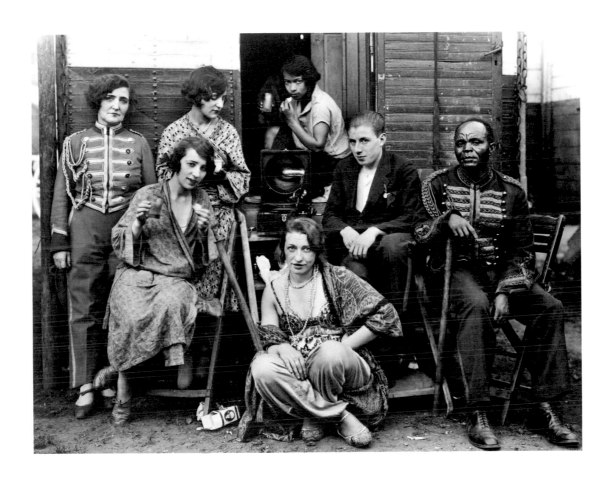

August Sander *Circus People*, Düren, 1930. Gelatin silver print, 7½ x 9½ inches

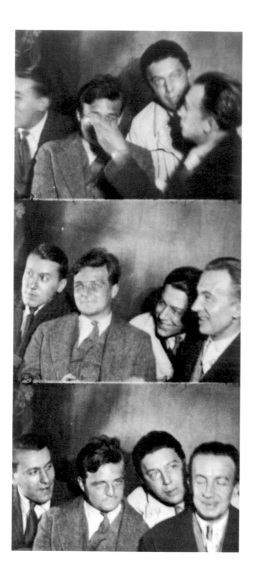

André Breton, René Char, Paul Éluard, Georges Sadoul *Photobooth Sequence*, 1931. (Left to right: René Char,
Georges Sadoul, André Breton, Paul Éluard.) Vintage gelatin silver print, 5⁷⁄₁₆ x 3½ inches

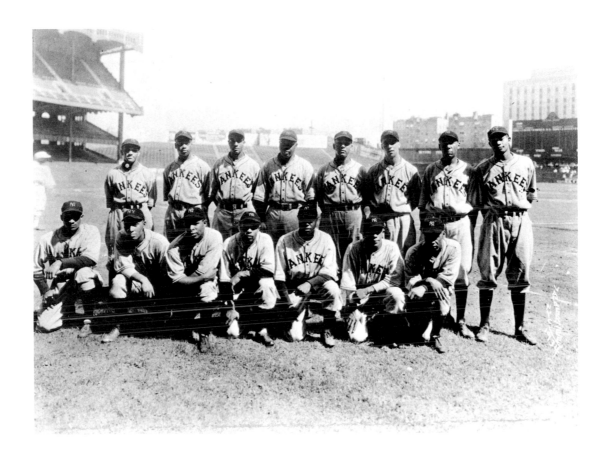

37

James VanDerZee *Black Yankees*, 1934. Gelatin silver print, 7½ x 9⅞ inches

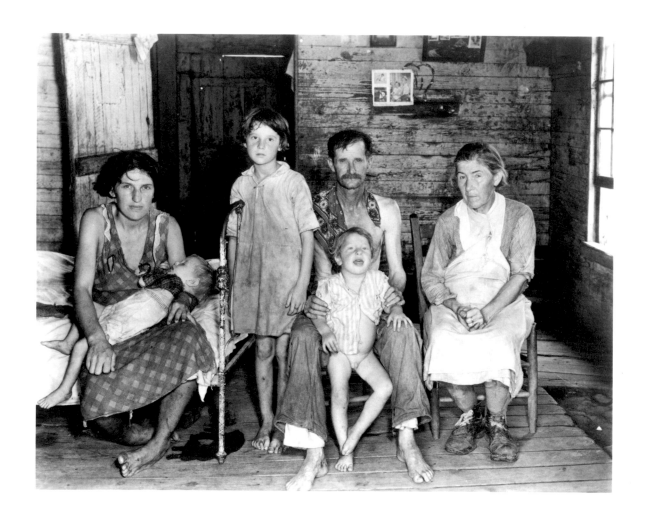

Walker Evans *Bud Fields, Cotton Sharecropper and Family*, Hale County, Alabama, 1936. Gelatin silver print, 8 x 10 inches

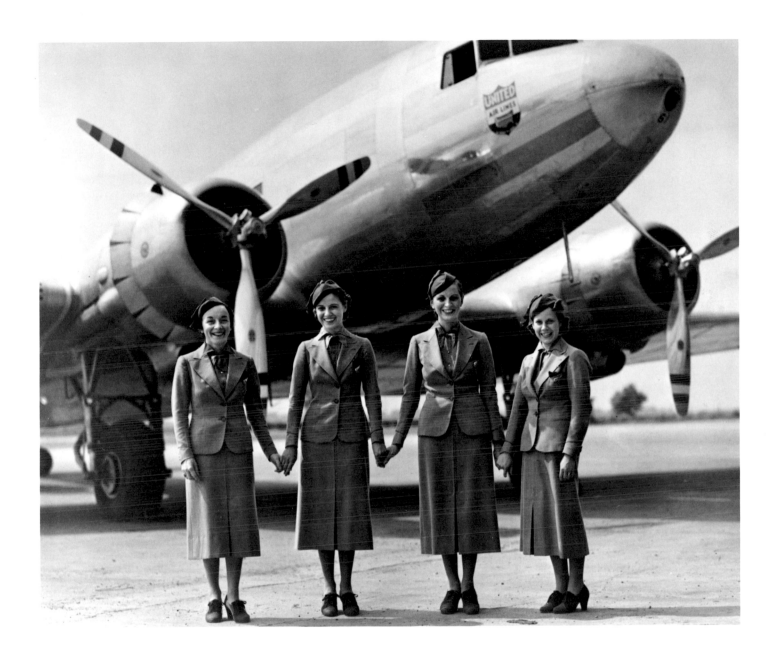

Gordon Coster *Untitled* (United Airlines Stewardesses), 1940s. Vintage gelatin silver print, 13⅞ x 16½ inches

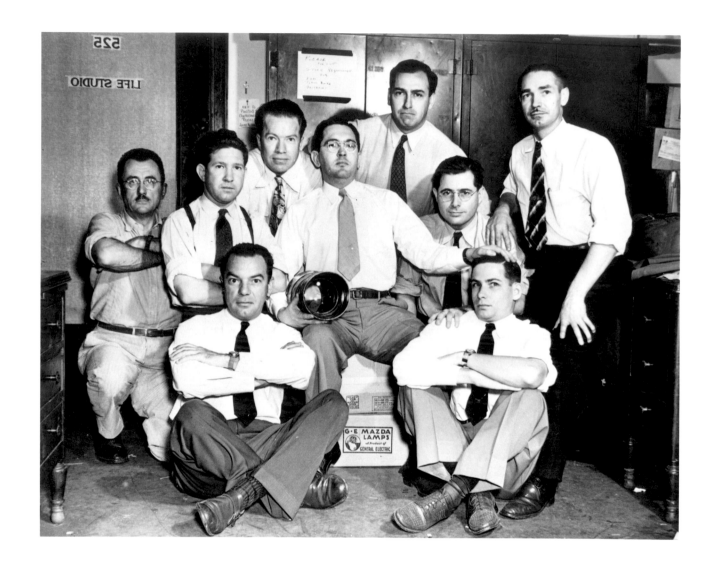

42

Robert H. Johnson *Untitled* (*Life* Magazine Photographers), 1940s. Vintage gelatin silver print, 10½ x 13¼ inches

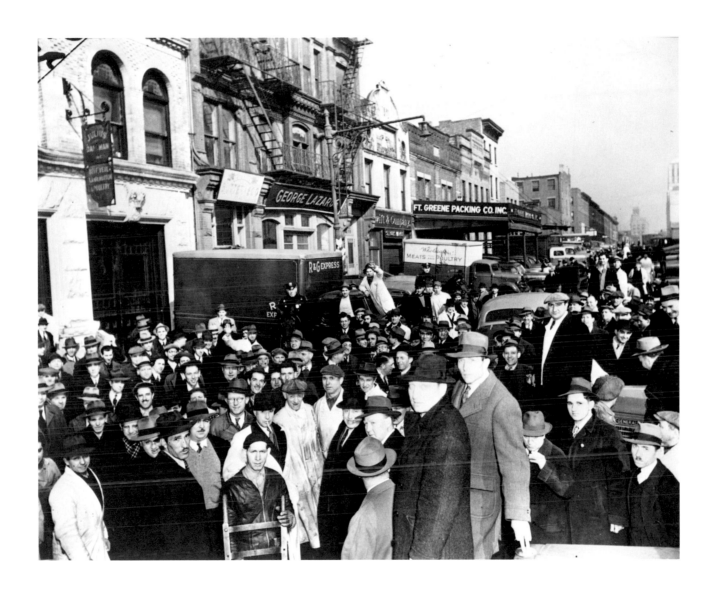

Weegee *Butcher's Strike*, 1943. Vintage gelatin silver print, 11¼ x 14 inches

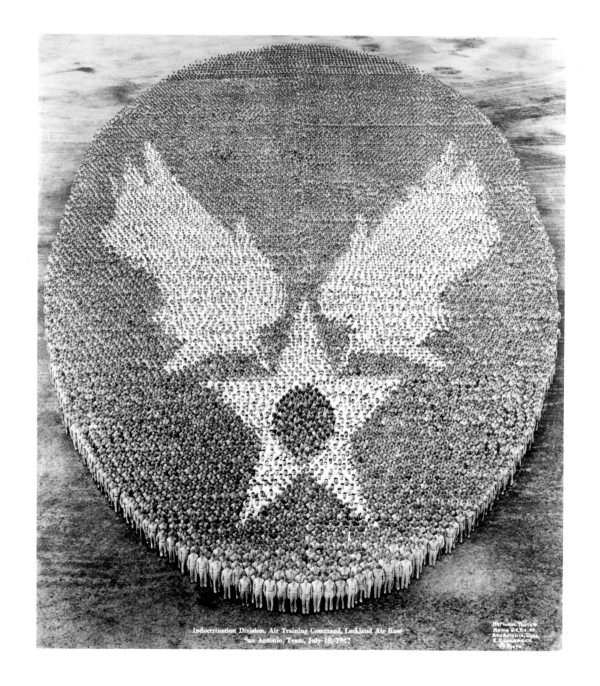

44

Eugene Omar Goldbeck *Indoctrination Division, Air Training Command, Lackland Air Base*, San Antonio, Texas, July 19, 1947. Gelatin silver print, 16 x 13⅜ inches

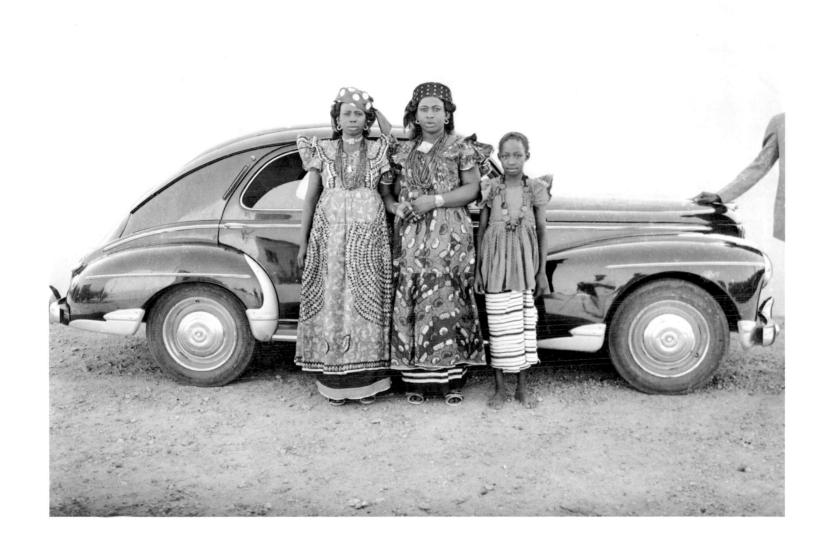

Seydou Keita *Untitled* (Family with Car), c. 1949–51. Gelatin silver print, 19½ x 23½ inches

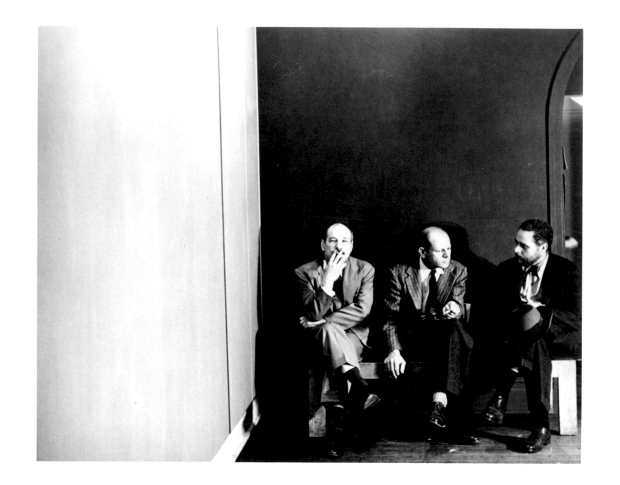

Hans Namuth *Barnett Newman, Jackson Pollock, Tony Smith*, 1950s. Vintage gelatin silver print, 8 x 10⅛ inches

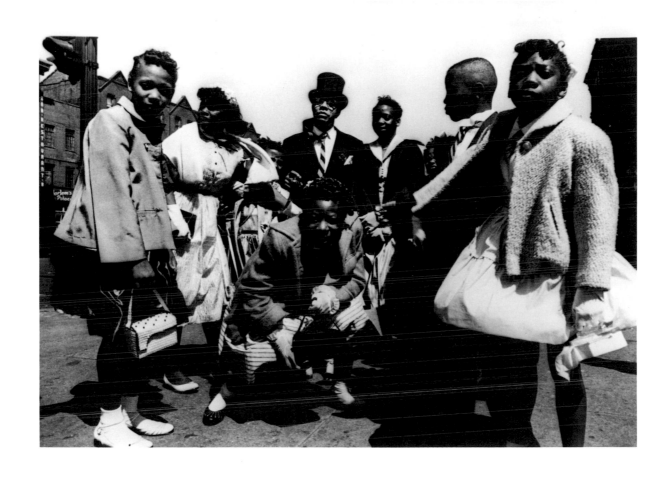

William Klein *Group, Kids & High Hat, Harlem, Easter*, 1955. Gelatin silver print, 10 x 14 inches

48

Danny Lyon *Clarksdale, Mississippi*, 1963. Gelatin silver print, 11 x 14 inches

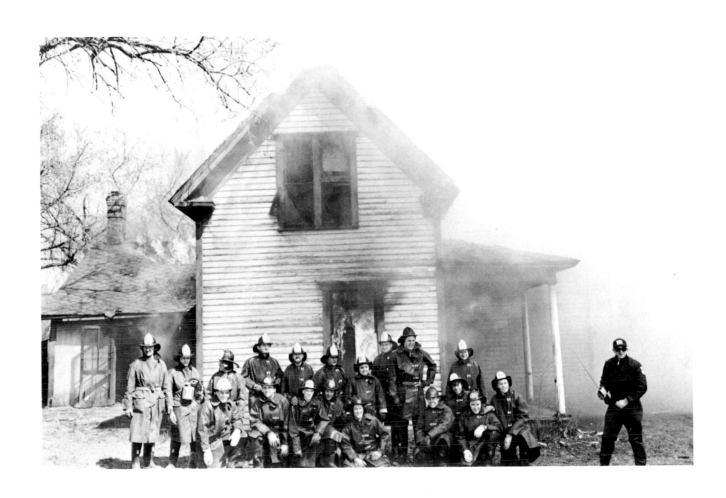

Lee Friedlander *Minneapolis*, 1966. Gelatin silver print, 11 x 14 inches

Duration Piece #14

Bradford, Massachusetts

At about 6:00 P.M., for seven consecutive days, (October 5–11), a group of people assembled to have a single photograph made as they assumed nearly the same pose and relative position. They wore, each evening, the same clothes and accessories: they even held similar drinks in order to give the appearance that the photographs had been made in rapid succession during one sitting.

A sign was flashed to the group before each photograph was taken: each person was instructed to think of nothing other than <u>one</u> of the two words printed on the sign, but in no way to allow that thought to find expression on his, or her, face. The photograph was made exactly five seconds after the words were flashed.

52

The words are listed below, in <u>no</u> sequential order, as they were actually shown to the group by the artist's assistant.

<u>NOTHING</u>	<u>SCREWING</u>	<u>BIRTH</u>	<u>FREE</u>	<u>CHOICE</u>	<u>PEACE</u>	<u>MONSTER</u>	<u>HATE</u>
ANYTHING	EATING	DEATH			WAR	KITTEN	LOVE

Seven photographs join with this statement to constitute the final form of this work.

May, 1970 Douglas Huebler

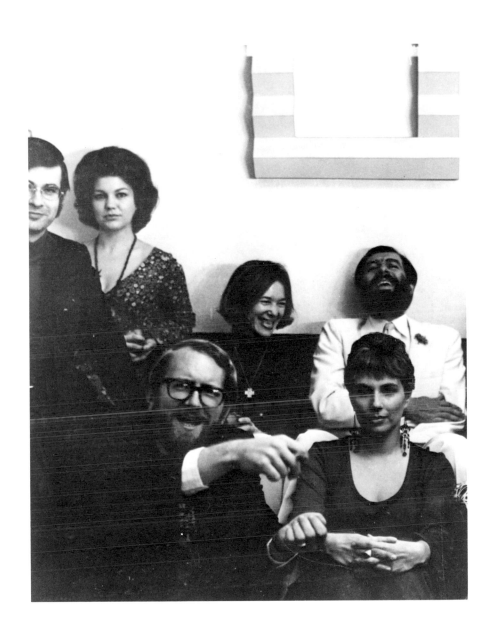

Douglas Huebler *Duration Piece #14* (detail), Bradford, MA, 1969/1994. 7 r/c plastic prints plus written text

54

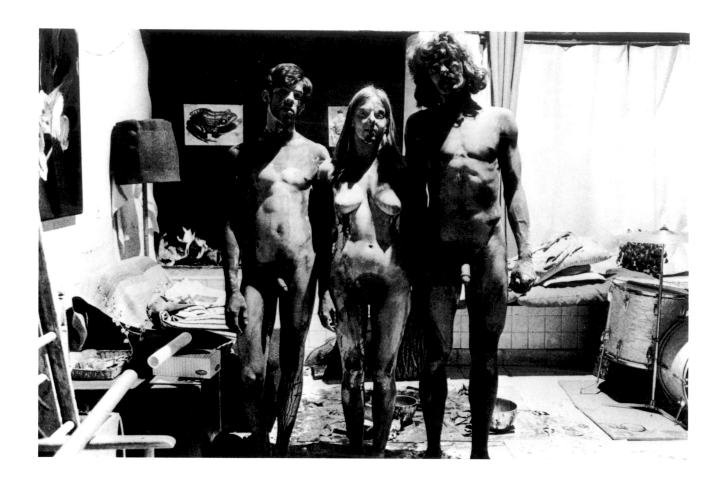

Larry Clark *Untitled*, 1970. Black-and-white photograph, 11 x 14 inches

Garry Winogrand *Untitled*, 1970s. From *Women are Beautiful*. Gelatin silver print, 11 x 14 inches

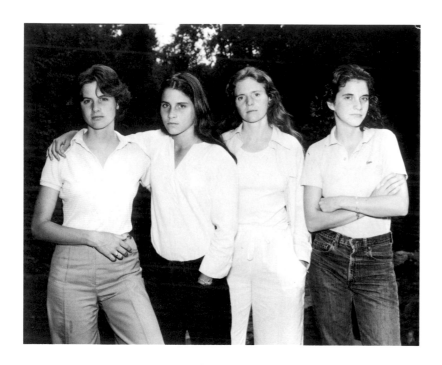

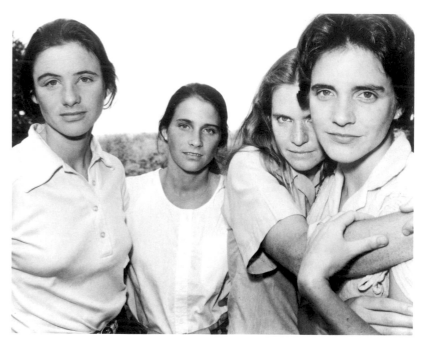

New Canaan, CT, 1975

East Greenwich, RI, 1980

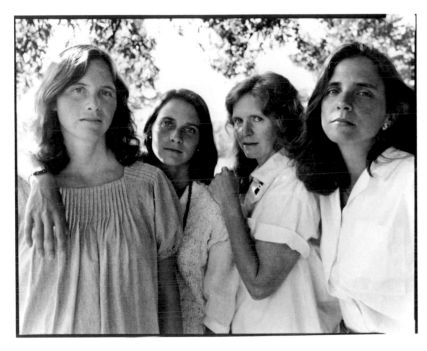

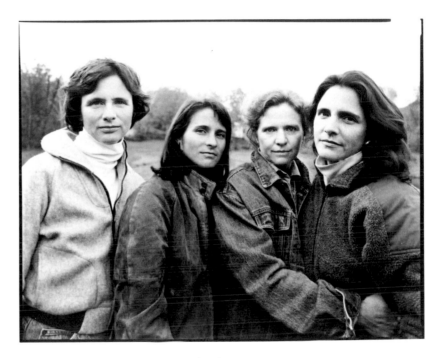

Allston, MA, 1985

Woodstock, VT, 1990

Nicholas Nixon *The Brown Sisters* (1975-94). Gelatin silver prints, 8 x 10 inches eac

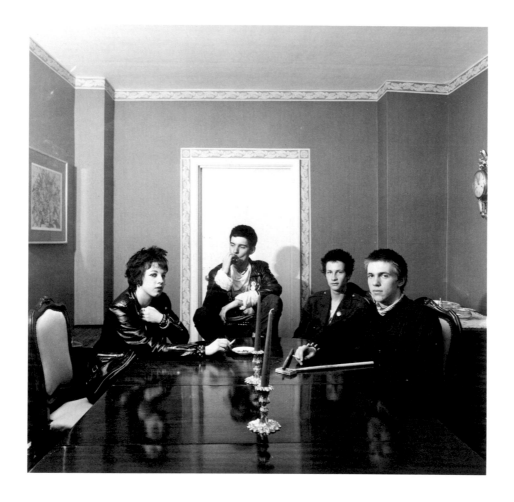

I am part of a group

called the Dulcit Drones

We are basically into Rebellion

into changing Youth today

Karen Knorr *I am part of a group/called the Dulcit Drones/We are basically into Rebellion/into changing Youth today.*, 1979–81.
From the series, *Belgravia*. Gelatin silver print, 20 x 16 inches

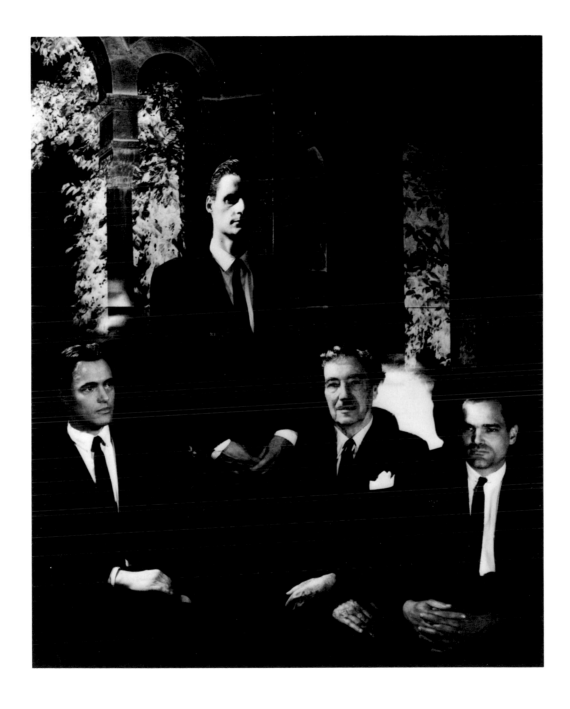

Clegg & Guttmann *Et in Arcadia Ego & Co.*, 1983. Cibachrome, 80 x 60 inches

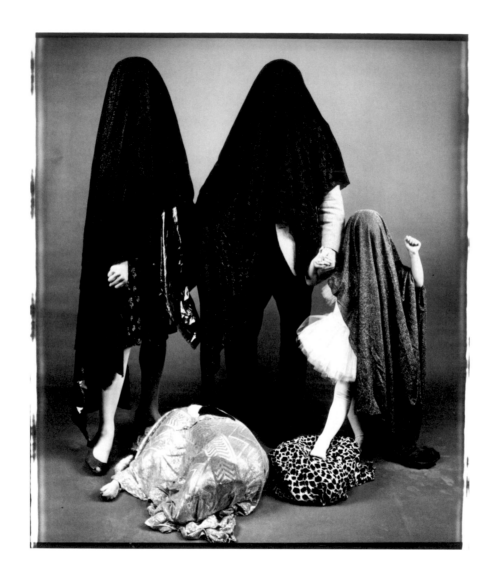

William Wegman *Closed-Covered*, 1984. Color Polaroid, 24 x 20 inches

Tina Barney *Tim, Phil and I*, 1989. Ektacolor Plus print, 48 x 60 inches

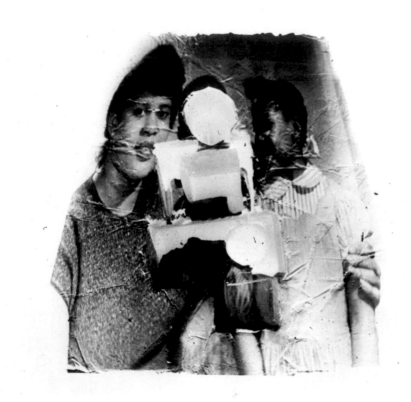

Darrell Ellis *Untitled*, 1990. Gelatin silver print, 11 x 14 inches

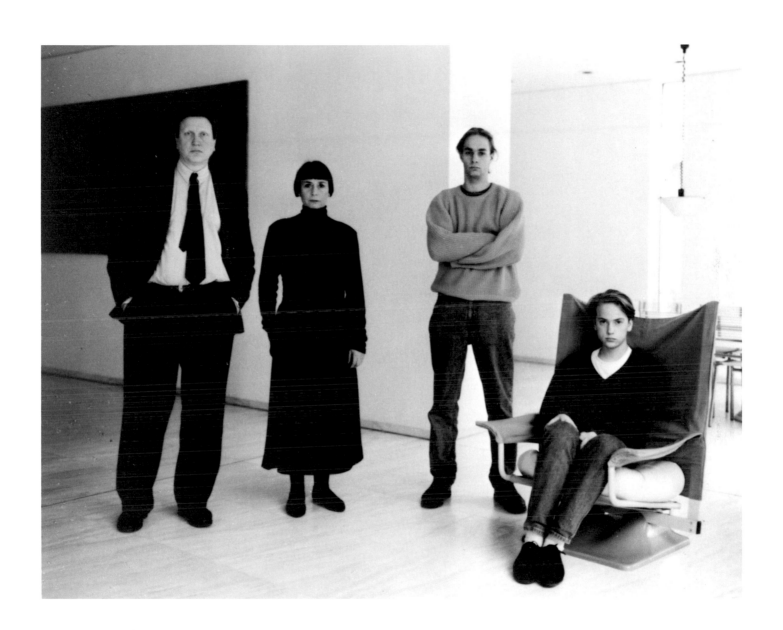

Thomas Struth *The Schäfer Family*, Düsseldorf, 1990. Type-C print, 38¾ x 43½ inches

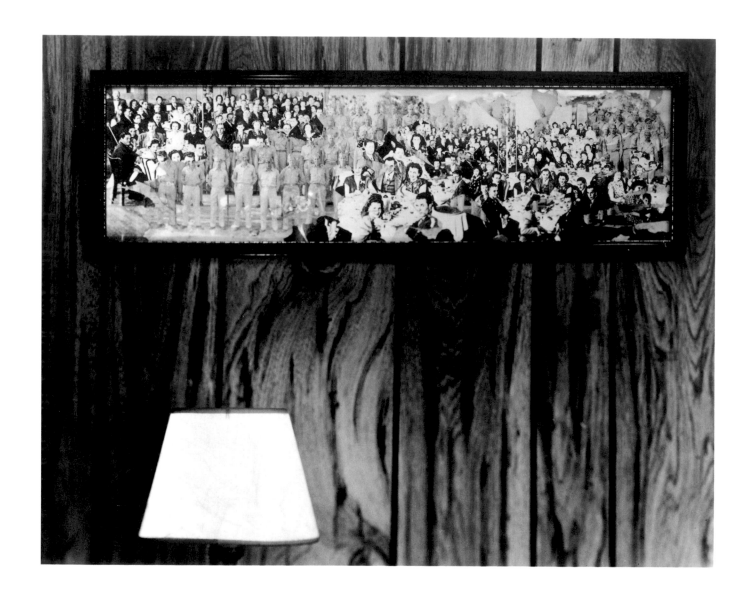

Anne Turyn *Untitled*, 1991. From *Illustrated Memories*, 1991. Type-C print, 16 x 20 inches

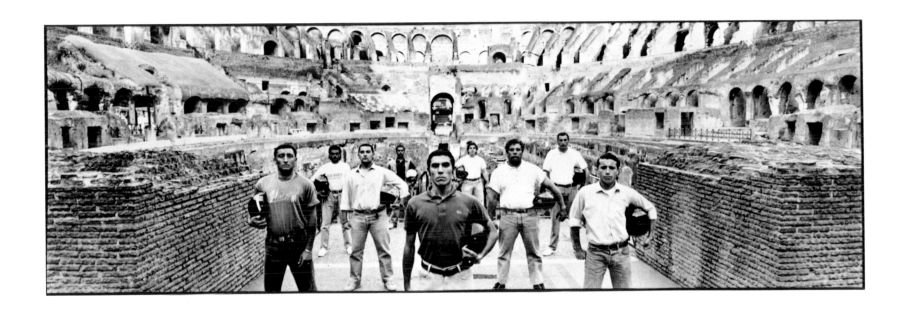

Frédéric Brenner *Amphitheatrum Flavium, Rome*, 1992. Gelatin silver print, 6 x 18⅛ inches

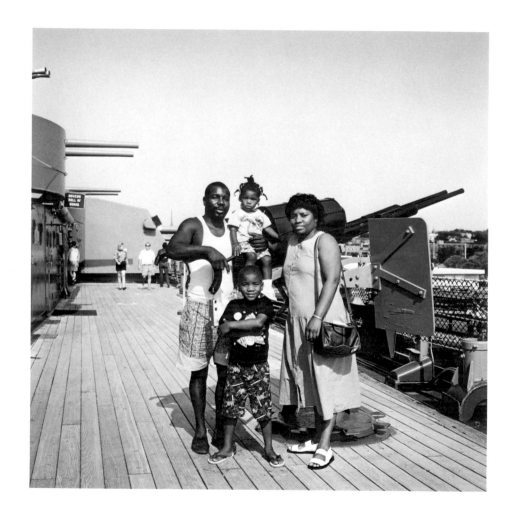

Jeffrey S. Kane *Four Member Family, USS N. Carolina*, 1992. Gelatin silver print, 11 x 11 inches

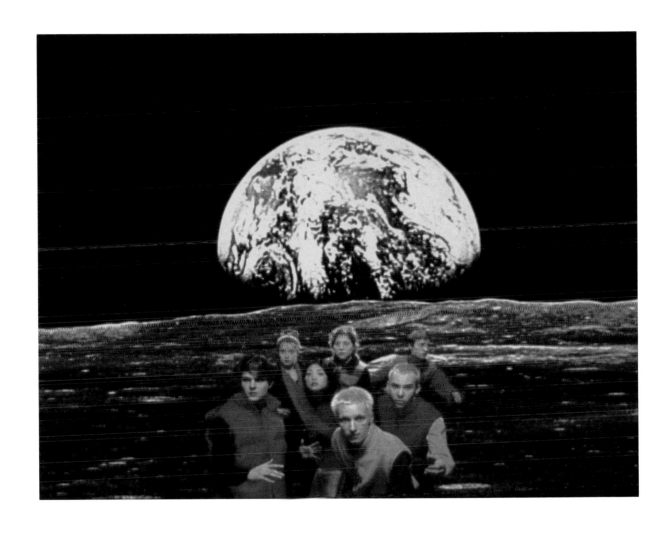

Art Club 2000 *Untitled* (Liberty Science Center/Earthrise), 1993. Color digital photograph, 3¹/₂ x 5 inches

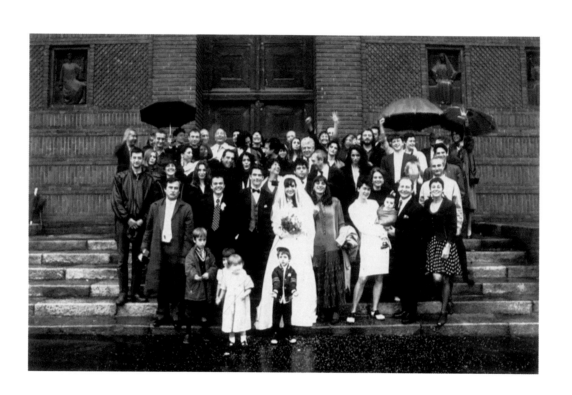

VI.
The Fake Marriage

Our improvised roadside marriage in Las Vegas didn't allow me the chance to fulfill the secret dream that I share with so many women: to one day wear a wedding dress. So, on Saturday, June 20, 1992, I decided to bring family and friends together on the steps of the church in Paris for a formal wedding picture. The photograph was followed by a mock civil ceremony performed by a real mayor and then a reception. The rice, the wedding cake, the white veil—nothing was missing. I crowned, with a fake marriage, the truest story of my life.

Sophie Calle *Autobiographical Stories (The Fake Marriage)*, 1993. Black-and-white photograph with text

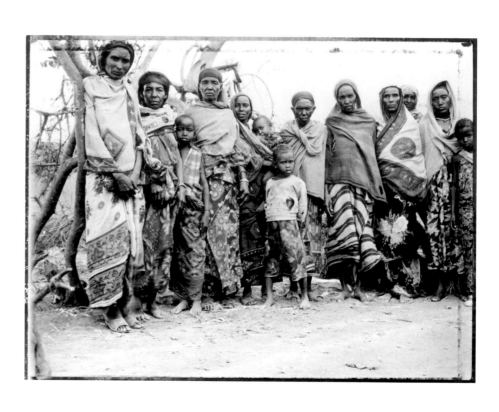

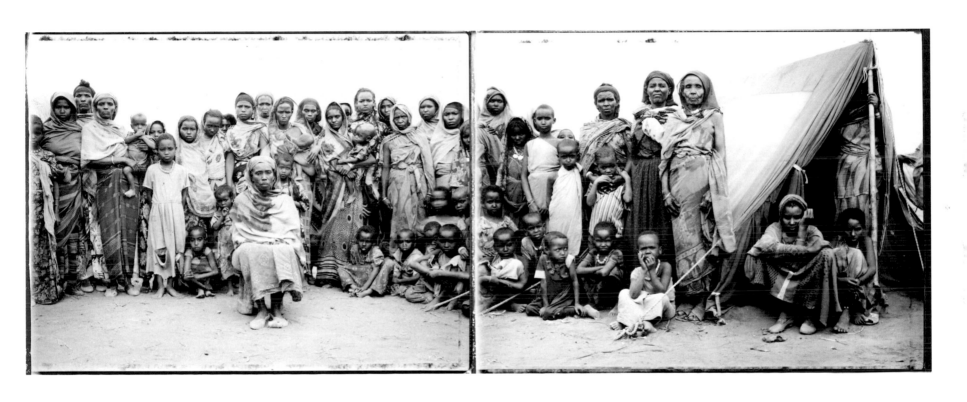

Fazal Sheikh *Gabbra Matriarch (seated at center left) with Gabbra women and children, Ethiopian refugee camp, Walda, Kenya*, 1993. Three toned gelatin silver prints, 16 x 20 inches each

72

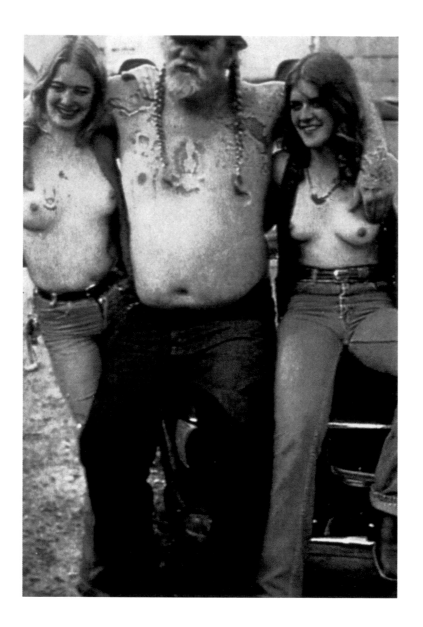

Richard Prince *Untitled* (Party), 1993. Ektacolor print, 20¾ x 16¾ inches

Checklist

Height precedes width

Anonymous
Boston Red Sox Baseball Team (Champions of the American League, Season 1912), 1912
Vintage gelatin silver postcard
3½ x 5⁷/₁₆ inches
Collection Timothy Baum, New York

Anonymous
Bauhaus Party, c. 1928
Vintage gelatin silver print
3¼ x 4⅝ inches
Collection Rick Wester, New York

Diane Arbus
Born: 1923, New York, New York
Died: 1971

Three Circus Ballerinas, NJ, 1964
Gelatin silver print
20 x 16 inches (paper size)
Courtesy Robert Miller Gallery, New York

A Family One Evening in a Nudist Camp, PA, 1965
Gelatin silver print
20 x 16 inches (paper size)
Courtesy Robert Miller Gallery, New York

Art Club 2000
(Patterson Beckwith, Gillian Haratani, Daniel McDonald, Shannon Pultz, Will Rollins, Siobian Spring, Craig Wadlin)

Untitled (Times Square/Gap Grunge 2), 1992–93
Type-C print
20 x 24 inches
Courtesy American Fine Arts, Co.,
Colin De Land Fine Art, New York

Untitled (Liberty Science Center/Earthrise), 1993
Color digital photograph
3½ x 5 inches
Courtesy American Fine Arts, Co.,
Colin De Land Fine Art, New York

Tina Barney
Born: 1945, New York, New York
Resides: New York, New York

The Graham Cracker Box, 1983
Chromogenic print
30 x 40 inches
Collection Louise Homburger and Bonnie Benrubi

Tim, Phil and I, 1989
Ektacolor Plus print
48 x 60 inches
Courtesy Janet Borden, Inc.

Frédéric Brenner
Born: 1959, Paris, France
Resides: Paris, France

Amphitheatrum Flavium, Rome, 1992
Gelatin silver print
6 x 18⅛ inches
Courtesy Howard Greenberg Gallery, New York

San Pietro, Rome, 1992
Gelatin silver print
6 x 18⅛ inches
Courtesy Howard Greenberg Gallery, New York

André Breton, René Char, Paul Éluard, Georges Sadoul

André Breton
Born: 1896, Tinchebray-sur-Orne, Brittany
Died: 1966

René Char
Born: 1907, L'isle-sur-Sorgue, France
Died: 1988

Paul Éluard (Eugène Grindel Éluard)
Born: 1895, Saint-Denis, France
Died: 1952

Georges Sadoul
Born: 1904, Paris, France
Died: 1969

Photobooth Sequence, 1931
Vintage gelatin silver print
5⁷/₁₆ x 3½ inches
Collection Timothy Baum, New York

Burckholder
Mansfield Motor Cyclists, July 18, 1915
Vintage gelatin silver print
8¾ x 37¼ inches
Keith de Lellis Collection, New York

Sophie Calle
Born: 1953, Paris, France
Resides: Paris, France

*Autobiographical Stories
(The Fake Marriage)*, 1993
Black-and-white photograph with text
Image: 45½ x 65¾ inches
Text: 18½ x 18½ inches
Courtesy the artist and Luhring Augustine,
New York

Central Studios, Atlantic City, NJ
Miss America Pageant, 1941
Vintage gelatin silver print
10 x 24 inches
Collection Jeffrey Hoffeld and Company, Inc.

Martín Chambi
Born: 1891, Puno, Peru
Died: 1973

Franciscanos con el Señor Blaisdell, c. 1928
(Mr. Blaisdell in the Franciscan Community)
Gelatin silver print
6¹³/₁₆ x 9⅛ inches
Collection Stephen Benjamin

74

Soldiers and Child, c. 1930
Gelatin silver print
6¾ x 9⅛ inches
Collection Stephen Benjamin

Carnival Costume Party, Cuzco, c. 1930
Gelatin silver print
6⅞ x 9¼ inches
Collection Stephen Benjamin

Wedding Portrait (Family Group), c. 1930
Gelatin silver print
6¹³⁄₁₆ x 9⅛ inches
Collection Stephen Benjamin

Larry Clark
Born: 1943, Tulsa, Oklahoma
Resides: New York, New York

Untitled, 1970
Black-and-white photograph
11 x 14 inches
Courtesy the artist and Luhring Augustine,
New York

Untitled, 1970
Black-and-white photograph
11 x 14 inches
Courtesy the artist and Luhring Augustine,
New York

Clegg & Guttmann

Michael Clegg
Born: 1957, Dublin, Ireland
Resides: Köln, Germany

Martin Guttmann
Born: 1957, Jerusalem, Israel
Resides: New York, New York

Et in Arcadia Ego & Co., 1983
Cibachrome
80 x 60 inches
Collection Alice and Marvin Kosmin

Gordon Coster
Born: 1906, Baltimore, Maryland
Resides: Chicago, Illinois

Untitled (World War II Pilots), 1940s
Vintage gelatin silver print
11 x 13⅞ inches
Keith de Lellis Collection, New York

Untitled (United Airlines Stewardesses), 1940s
Vintage gelatin silver print
13⅞ x 16½ inches
Keith de Lellis Collection, New York

Mike Disfarmer
Born: 1884, Indiana
Died: 1959

*George & Ethel Gage with his Mother Ida
and Children Loretta, Ida, Ivory, Jessie & Leon*,
1939–46
Gelatin silver print
11 x 14 inches
Courtesy Staley-Wise Gallery, New York

Buel, Elbert, and Jewell Haile, brothers,
1939–46
Gelatin silver print
11 x 14 inches
Courtesy Staley-Wise Gallery, New York

Untitled (Woman with Four Girls), 1939–46
Gelatin silver print
11 x 14 inches
Courtesy Staley-Wise Gallery, New York

Darrell Ellis
Born: 1958, New York, New York
Died: 1992

Untitled, 1990
Gelatin silver print
11 x 14 inches
Courtesy the Estate of Darrell Ellis

Elliott Erwitt
Born: 1928, Paris, France
Resides: New York, New York

U.S.A., 1962
Gelatin silver print
16 x 20 inches
Courtesy the artist/Magnum Photos, Inc.

U.S.A., 1964
Gelatin silver print
16 x 20 inches
Courtesy the artist/Magnum Photos, Inc.

New Jersey, U.S.A., 1966
Gelatin silver print
20 x 16 inches
Courtesy the artist/Magnum Photos, Inc.

The Annual Meeting, Paris, 1988
Color photograph
35½ x 53 inches
Courtesy the artist/Magnum Photos, Inc.

Walker Evans
Born: 1903, St. Louis, Missouri
Died: 1975

Bud Fields, Cotton Sharecropper and Family,
Hale County, Alabama, 1936
Gelatin silver print
8 x 10 inches
Collection Davison Art Center,
Wesleyan University, Middletown, CT

T. Lux Feininger
Born: 1910, Berlin, Germany
Resides: Cambridge, Massachusetts

Group 'Charlestoning' on Bauhaus Roof, late 1920s
(From left to right: Heinz Loew, Josef Albers,
Andor Weininger, Clements Roseler, Werner
Jackson, Marcel Breuer, Heinrich Koch, and Xanti
Schawinsky)
Vintage gelatin silver print
3¼ x 4½ inches
Collection Rick Wester, New York

Lee Friedlander
Born: 1934, Aberdeen, Washington
Resides: New City, New York

Minneapolis, 1966
Gelatin silver print
11 x 14 inches
Courtesy Fraenkel Gallery, San Francisco

Arnold Genthe
Born: 1869, Berlin, Germany
Died: 1942

Old Chinatown, c. 1909
Vintage gelatin silver print
5½ x 8⅞ inches
Courtesy Zabriskie Gallery, New York

Eugene Omar Goldbeck
Born: 1892, San Antonio, Texas
Died: 1986

*Indoctrination Division, Air Training Command,
Lackland Air Base*, San Antonio, Texas, July 19, 1947
Gelatin silver print
16 x 13⅜ inches
Private collection, New York

Lewis Hine
Born: 1874, Oshkosh, Wisconsin
Died: 1940

Untitled (Four Newspaper Boys), 1910–14
Vintage gelatin silver print
3½ x 4½ inches
Courtesy Zabriskie Gallery, New York

Untitled (Six Girls), 1910–12
Vintage gelatin silver print
4¾ x 5½ inches
Courtesy Zabriskie Gallery, New York

Douglas Huebler
Born: 1924, Ann Arbor, Michigan
Resides: Truro, Massachusetts

Duration Piece #14, Bradford, MA, 1969/1994
7 r/c plastic prints plus written text
Photographs: 9⅜ x 7⅜ inches each
Text: 8½ x 11 inches
Courtesy Holly Solomon Gallery, New York

Robert H. Johnson
Untitled (*Life* Magazine Photographers), 1940s
Vintage gelatin silver print
10½ x 13¼ inches
Keith de Lellis Collection, New York

Jeffrey S. Kane
Born: 1961, Woonsocket, Rhode Island
Resides: New York, New York

Salt Lake Jesus, 1985
Gelatin silver print
11 x 11 inches
Courtesy the artist

*Four Member Family,
USS N. Carolina*, 1992
Gelatin silver print
11 x 11 inches
Courtesy the artist

Seydou Keita
Born: 1923, Bamako, Mali
Resides: Bamako, Mali

Untitled (Family with Car), c. 1949–51
Gelatin silver print
19½ x 23½ inches
Courtesy The Pigozzi Collection

Untitled (Five Men), 1949–51
Gelatin silver print
23½ x 19½ inches
Courtesy The Pigozzi Collection

Untitled (Family), c. 1952–55
Gelatin silver print
23½ x 19½ inches
Courtesy The Pigozzi Collection

Untitled (Three Men), c. 1952–55
Gelatin silver print
23½ x 19½ inches
Courtesy The Pigozzi Collection

Untitled (Two Women, Two Children), c. 1952–55
Gelatin silver print
23½ x 19½ inches
Courtesy The Pigozzi Collection

Untitled (Old Man with Two Wives and Two
Children), c. 1956–57
Gelatin silver print
23½ x 19½ inches
Courtesy The Pigozzi Collection

William Klein

Born: 1928, New York, New York
Resides: Paris, France

Group, Kids & High Hat, Harlem, Easter, 1955
Gelatin silver print
10 x 14 inches
Courtesy Galerie Zabriskie, Paris

Club Allegro Fortissimo, Paris, 1990
Gelatin silver print
9¼ x 14 inches
Courtesy Howard Greenberg Gallery, New York

Karen Knorr

Born: 1954, Frankfurt am Main, Germany
Resides: London, England

*I am part of a group
called the Dulcit Drones
We are basically into Rebellion
into changing Youth today.*, 1979–81
From the series, *Belgravia*
Gelatin silver print
20 x 16 inches
Courtesy the artist

*If Community life
Is to be Lived at its Best
the greatest good of
the greatest number
must be considered before
the Desires of the Few.*, 1981–83
From the series, *Gentlemen*
Gelatin silver print
24 x 20 inches
Courtesy the artist

Dorothea Lange

Born: 1895, Hoboken, New Jersey
Died: 1965

Migrant Mother, Nipomo, California, 1936
(printed 1976)
Gelatin silver print
14 x 11 inches
Collection Davison Art Center, Wesleyan University,
Middletown, CT. Gift of Russell G. D'Oench, Jr.

Danny Lyon

Born: 1942, Brooklyn, New York
Resides: New York, New York

Clarksdale, Mississippi, 1963
Gelatin silver print
11 x 14 inches
Courtesy Jan Kesner Gallery, Los Angeles

Man Ray

Born: 1890, Philadelphia, PA
Died: 1976

Group of Surrealists at Tristan Tzara's House,
c. 1930
Vintage gelatin silver print
2½ x 3¾ inches
Collection Timothy Baum, New York

Mole and Thomas

Arthur S. Mole
Born: 1889, England
Died: 1983

John D. Thomas
Born: Place and date unknown
Died: 1947

The Living Uncle Sam, Camp Lee, January 13, 1919
Vintage gelatin silver print
14 x 11 inches
Keith de Lellis Collection, New York

Hans Namuth

Born: 1915, Essen, Germany
Died: 1991

*Barnett Newman, Jackson Pollock,
Tony Smith*, 1950s
Vintage gelatin silver print
8 x 10⅛ inches
Keith de Lellis Collection, New York

Nicholas Nixon

Born: 1947, Detroit, Michigan
Resides: Cambridge, Massachusetts

The Brown Sisters, (1975–94)
Gelatin silver prints
8 x 10 inches each
Courtesy the artist and Zabriskie Gallery, New York

New Canaan, CT, 1975
Hartford, CT, 1976
Cambridge, MA, 1977
Harwich, MA, 1978
Marblehead, MA, 1979
East Greenwich, RI, 1980
Cincinnati, OH, 1981
Ipswich, MA, 1982
Brighton, MA, 1983
Truro, MA, 1984
Allston, MA, 1985
Cambridge, MA, 1986
Chatham, MA, 1987
Wellesley, MA, 1988
Cambridge, MA, 1989
Woodstock, VT, 1990
Watertown, MA, 1991
Concord, MA, 1992
Boston, MA, 1993
Grantham, NH, 1994

Richard Prince
Born: 1949, Panama Canal Zone
Resides: New York, New York

Untitled (Party), 1993
Ektacolor print
20¾ x 16¾ inches
Courtesy Barbara Gladstone Gallery, New York

Untitled (Party), 1993
Ektacolor print
20¾ x 16¾ inches
Courtesy Barbara Gladstone Gallery, New York

August Sander
Born: 1876, Herdorf, Germany
Died: 1964

August Sander and His Family, Cologne, 1911
Gelatin silver print
7½ x 10 inches
Courtesy Sander Gallery, New York

Working Class Children, 1930/32
Gelatin silver print
10 x 7 inches
Courtesy Sander Gallery, New York

Circus People, Düren, 1930
Gelatin silver print
7½ x 9½ inches
Courtesy Sander Gallery, New York

Protestant Missionaries, Cologne, 1931
Gelatin silver print
10 x 7 inches
Courtesy Sander Gallery, New York

Fazal Sheikh
Born: 1965, New York, New York
Resides: Princeton, New Jersey

*Gabbra Matriarch with Gabbra Women
and children, Ethiopian refugee camp,
Walda, Kenya*, 1993
Three toned gelatin silver prints
16 x 20 inches each
Courtesy Pace/MacGill Gallery, New York

*Traditional birthing attendant, Nyabahire
Esteri, holding newborns Nsabimana ("I beg
something from God") and Mukanzabonimpa
("God will give me, but I don't know when")
with their mothers Kanyuange, Mukabatazi
and Mukabatazi's mother, Rwandan refugee
camp, Lumasi, Tanzania*, 1994
Toned gelatin silver print
20 x 16 inches
Courtesy Pace/MacGill Gallery, New York

*Kulaso Whisky's Three Wives, Maria Vinti,
Sarah January, and Shika Francisco, Mozambican
refugee camp, Nyamithuthu, Malawi*, 1994
Toned gelatin silver print
24 x 20 inches
Courtesy Pace/MacGill Gallery, New York

Thomas Struth
Born: 1954, Geldern/Lower Rhein, Germany
Resides: Düsseldorf, Germany

The Schäfer Family, Düsseldorf, 1990
Type-C print
38¾ x 43½ inches
Courtesy Marian Goodman Gallery, New York

The Ghez Family, Chicago, 1990
Type-C print
39½ x 46 inches
Courtesy Marian Goodman Gallery, New York

Anne Turyn
Born: 1954, New York, New York
Resides: New York, New York

Untitled, 1991
From *Illustrated Memories*, 1991
Type-C print
16 x 20 inches
Courtesy the artist

Untitled, 1991
From *Illustrated Memories*, 1991
Type-C print
16 x 20 inches
Courtesy the artist

James VanDerZee
Born: 1886, Lenox, Massachusetts
Died: 1983

Untitled (Banquet), 1925
Vintage gelatin silver print
7¾ x 9⅝ inches
Courtesy Howard Greenberg Gallery, New York

Untitled (Children Swimming), 1928
Vintage gelatin silver print
4½ x 6⅞ inches
Courtesy Howard Greenberg Gallery, New York

Black Yankees, 1934
Gelatin silver print
7½ x 9⅞ inches
Courtesy Howard Greenberg Gallery, New York

Nuns, NYC, 1952
Vintage gelatin silver print
5½ x 9¾ inches
Courtesy Howard Greenberg Gallery, New York

*Rabbi Matthews and the Moorish
Zionist Temple of Moorish Jews*, 1929
Gelatin silver print
7¾ x 9⅝ inches
Courtesy Howard Greenberg Gallery, New York

Weegee (Arthur Fellig)

Born: 1899, Zloczew, Austria (now Poland)
Died: 1968

Butcher's Strike, 1943
Vintage gelatin silver print
11¼ x 14 inches
Keith de Lellis Collection, New York

William Wegman

Born: 1943, Holyoke, Massachusetts
Resides: New York, New York

Closed-Covered, 1984
Color Polaroid
24 x 20 inches
Courtesy Holly Solomon Gallery, New York

Garry Winogrand

Born: 1928, New York, New York
Died: 1984

Untitled, 1970s
From *Women are Beautiful*
Gelatin silver print
11 x 14 inches
Courtesy Zabriskie Gallery, New York

79

© 1995 Independent Curators Incorporated
799 Broadway, Suite 205
New York, NY 10003
212-254-8200 Fax: 212-477-4781

Editor: Marybeth Sollins
Design and typography: Russell Hassell
Lithography: The Studley Press
Edition of 2000

Library of Congress Catalogue Card Number:
 94-73722
ISBN: 0-916365-44-1